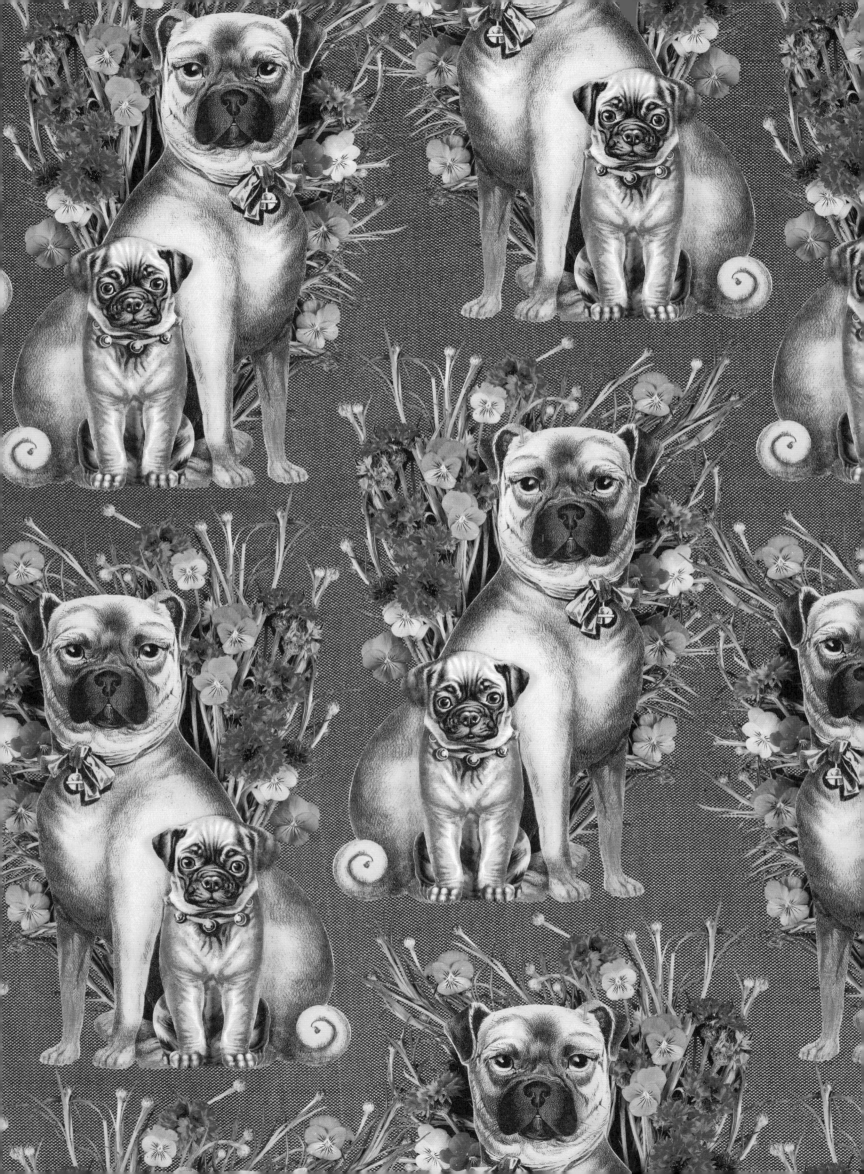

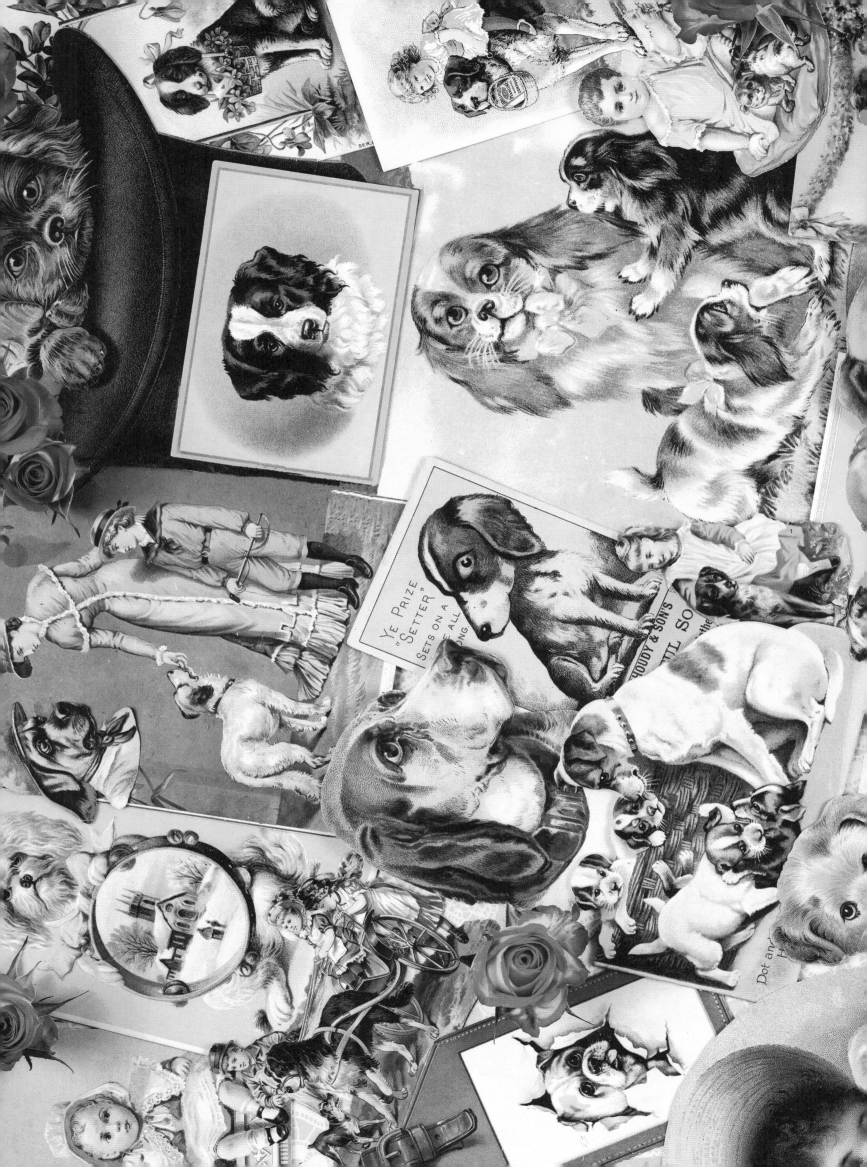

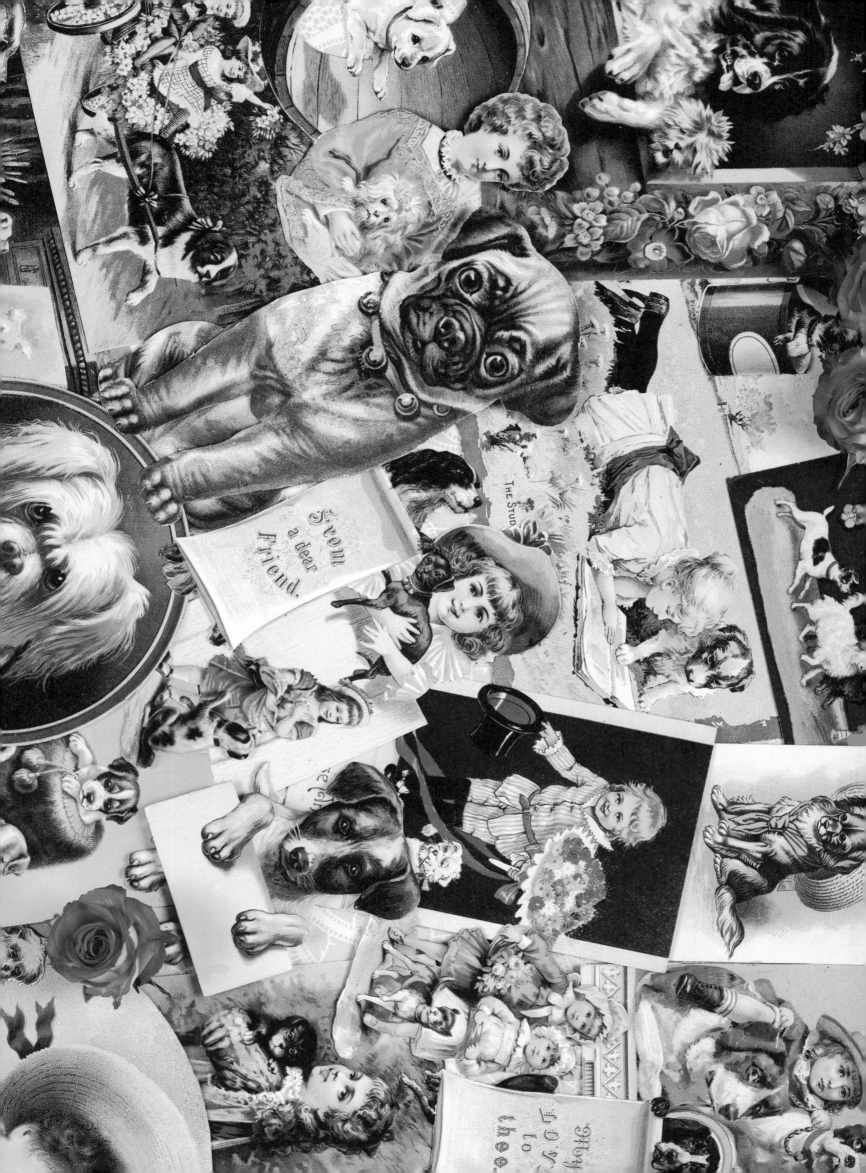

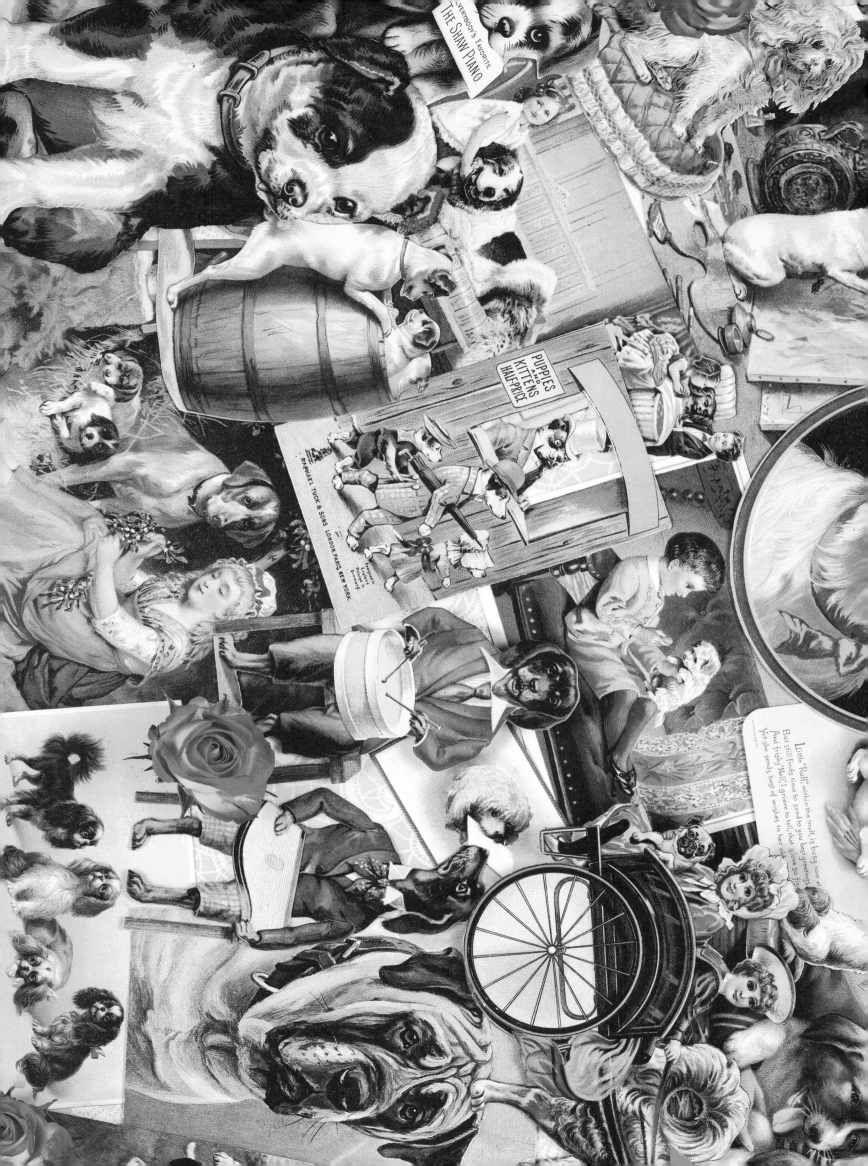

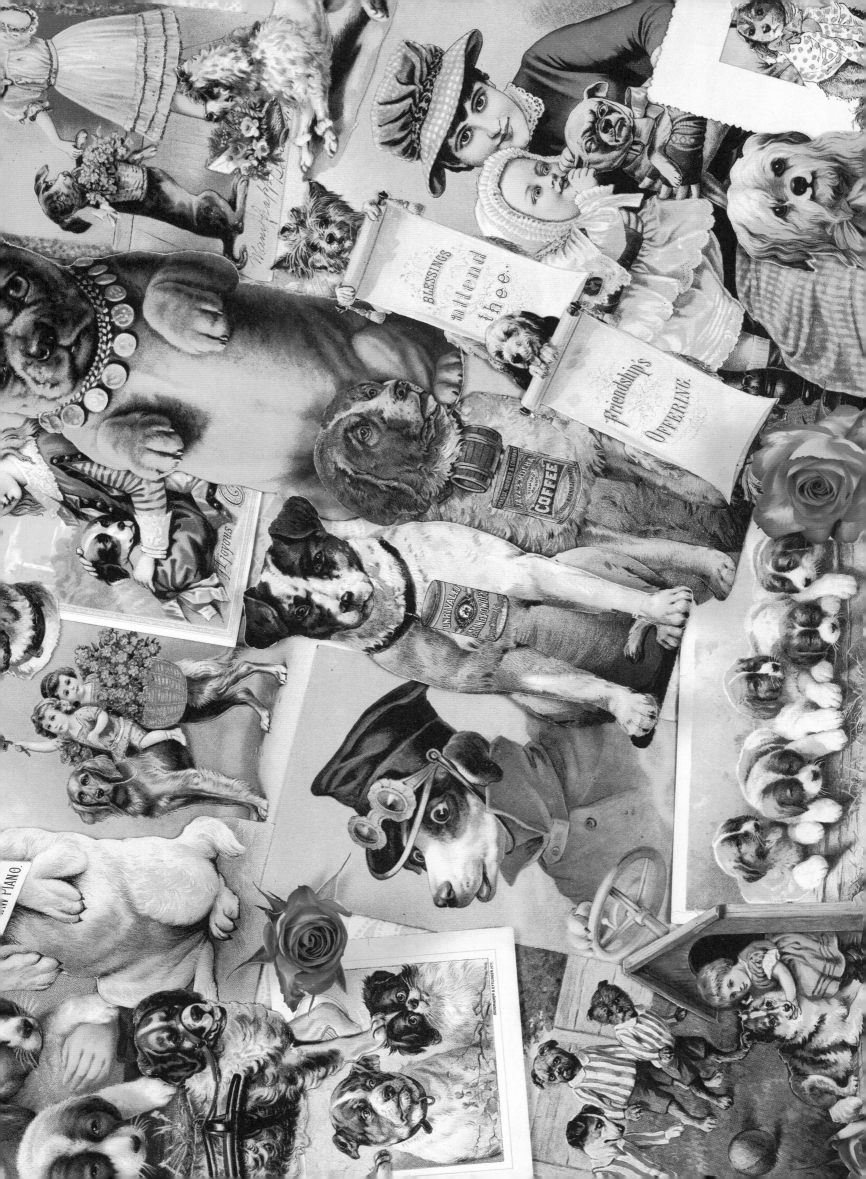

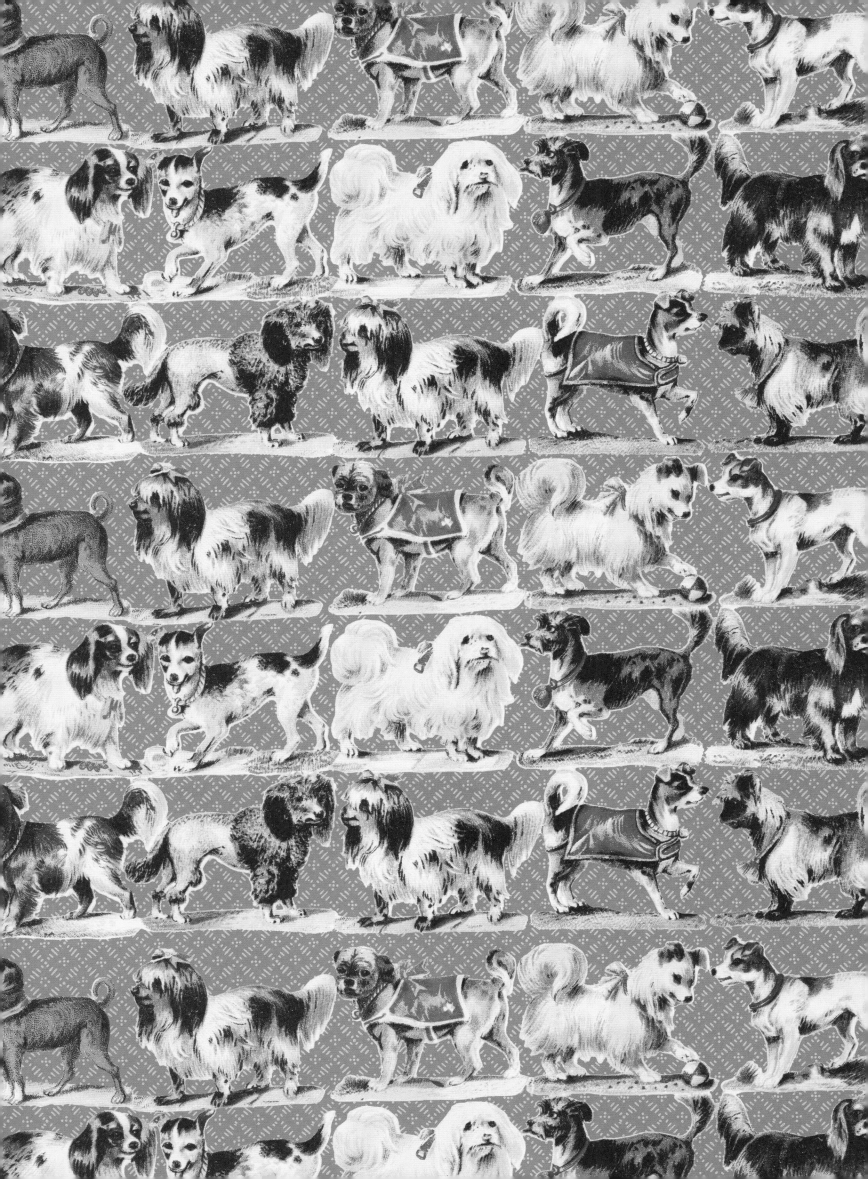

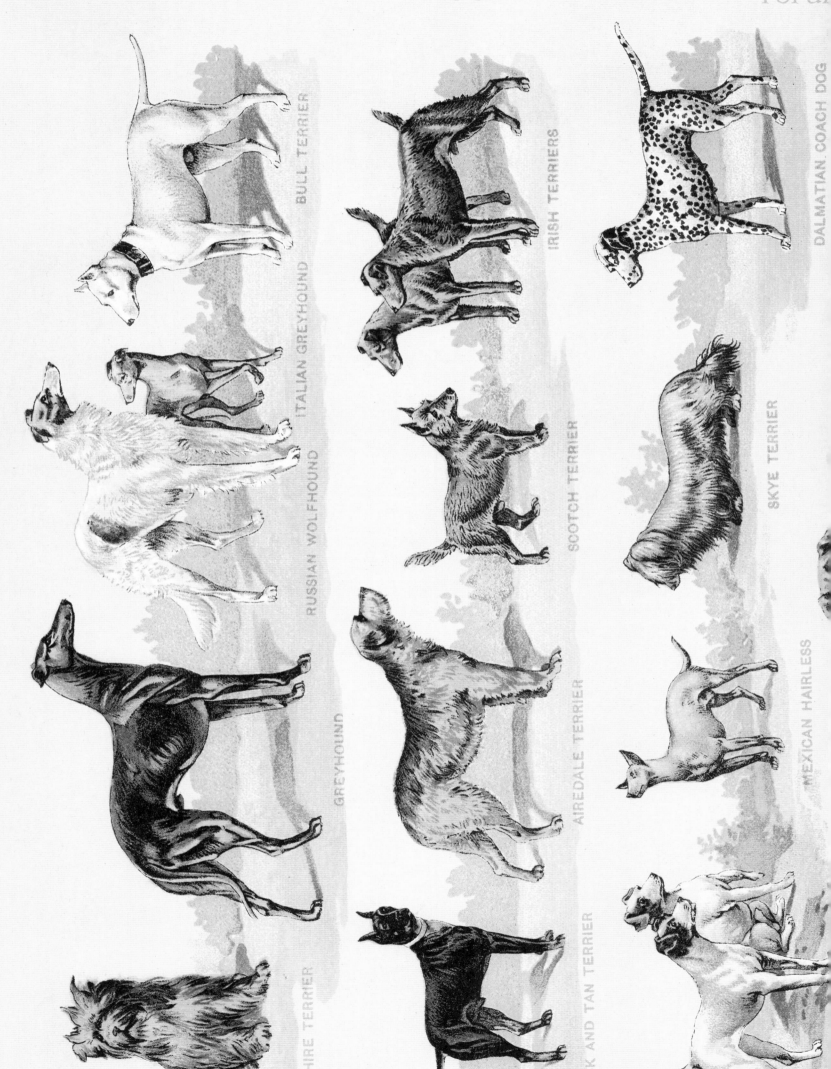

BULL TERRIER

ITALIAN GREYHOUND

IRISH TERRIERS

DALMATIAN COACH DOG

RUSSIAN WOLFHOUND

SCOTCH TERRIER

SKYE TERRIER

GREYHOUND

AIREDALE TERRIER

MEXICAN HAIRLESS

KSHIRE TERRIER

ACK AND TAN TERRIER

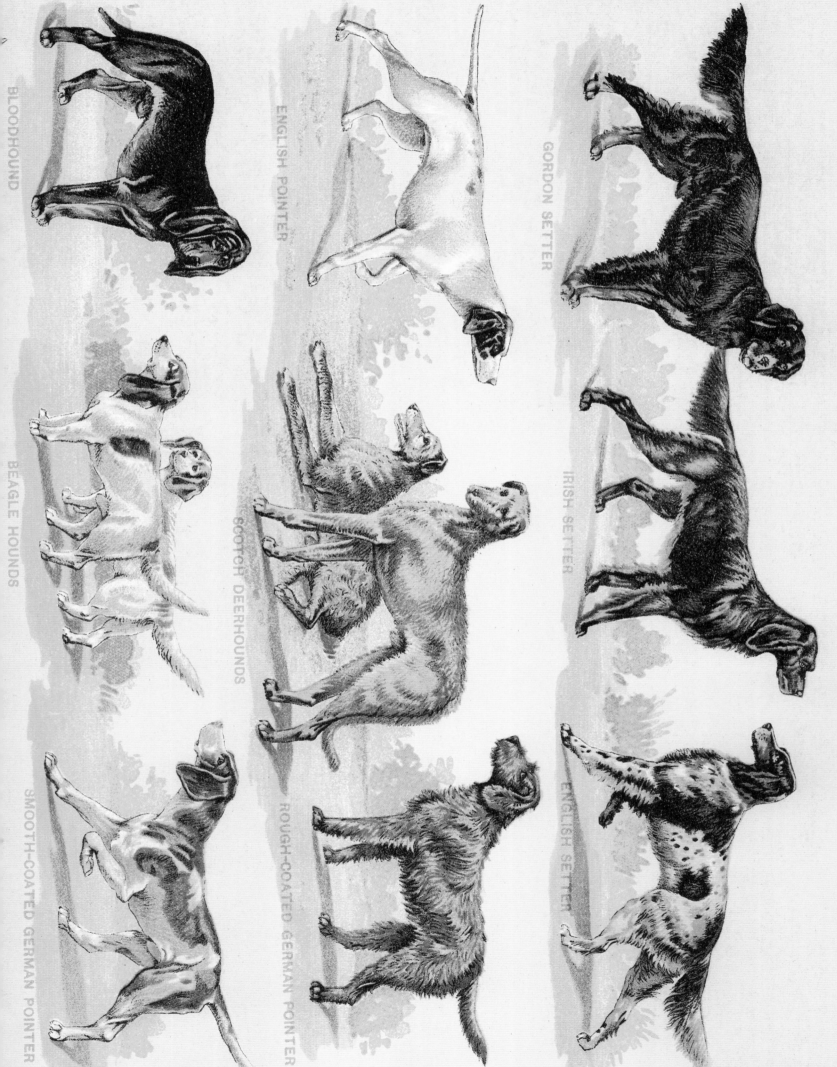

DS 1899

BLOODHOUND

ENGLISH POINTER

GORDON SETTER

BEAGLE HOUNDS

SCOTCH DEERHOUNDS

IRISH SETTER

SMOOTH-COATED GERMAN POINTER

ROUGH-COATED GERMAN POINTER

ENGLISH SETTER

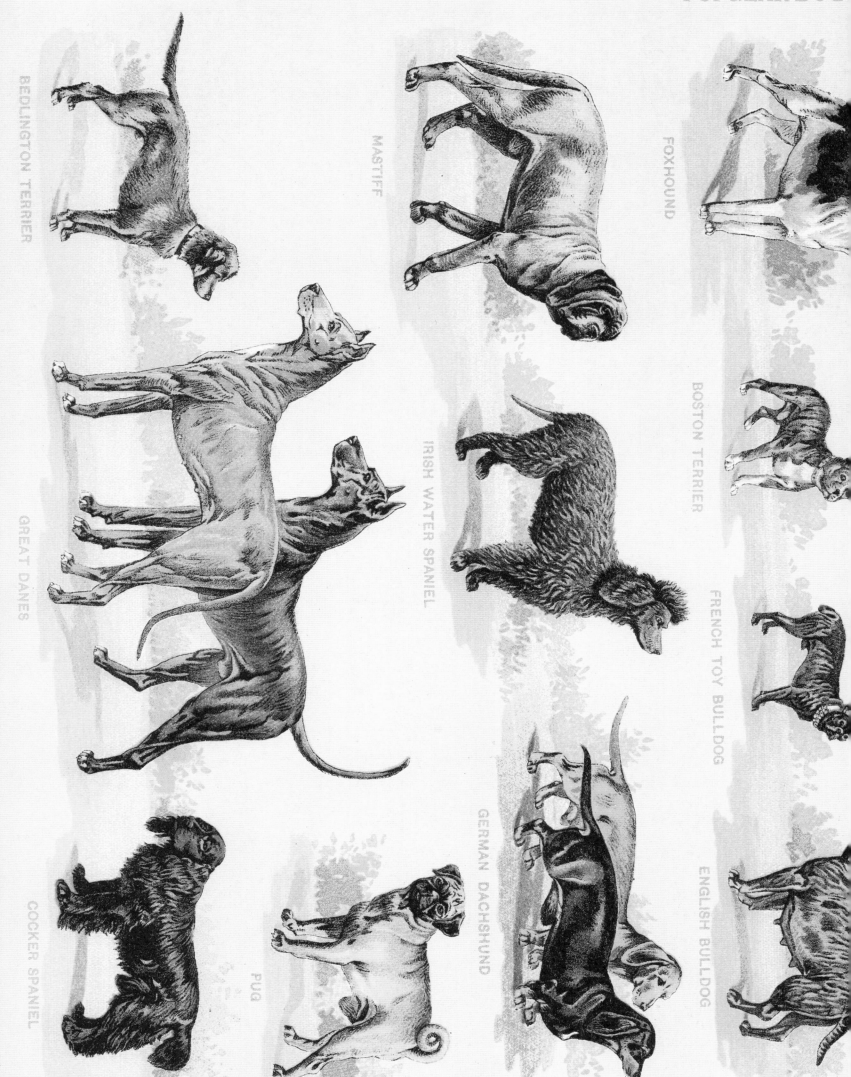

BEDLINGTON TERRIER

MASTIFF

FOXHOUND

GREAT DANES

IRISH WATER SPANIEL

BOSTON TERRIER

FRENCH TOY BULLDOG

COCKER SPANIEL

PUG

GERMAN DACHSHUND

ENGLISH BULLDOG

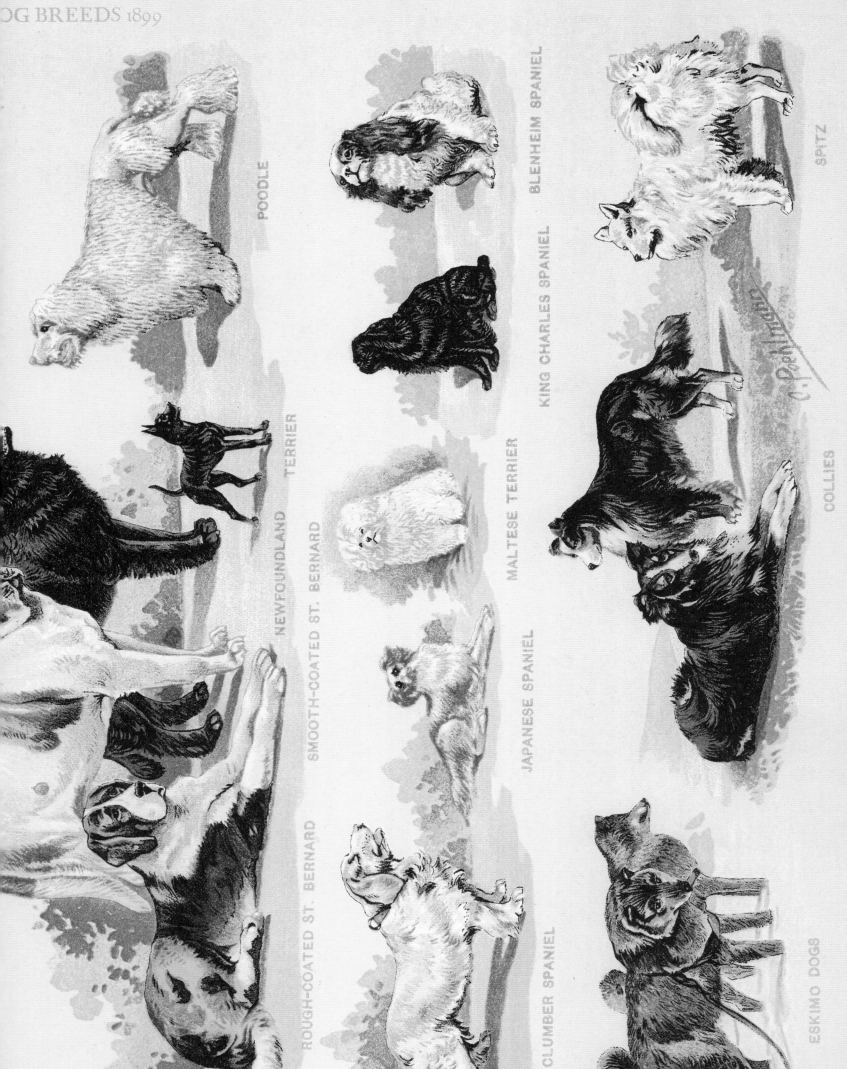

DOG BREEDS 1899

POODLE

NEWFOUNDLAND TERRIER

ROUGH-COATED ST. BERNARD

SMOOTH-COATED ST. BERNARD

MALTESE TERRIER

JAPANESE SPANIEL

CLUMBER SPANIEL

BLENHEIM SPANIEL

KING CHARLES SPANIEL

SPITZ

COLLIES

ESKIMO DOGS

C. Pechlinger

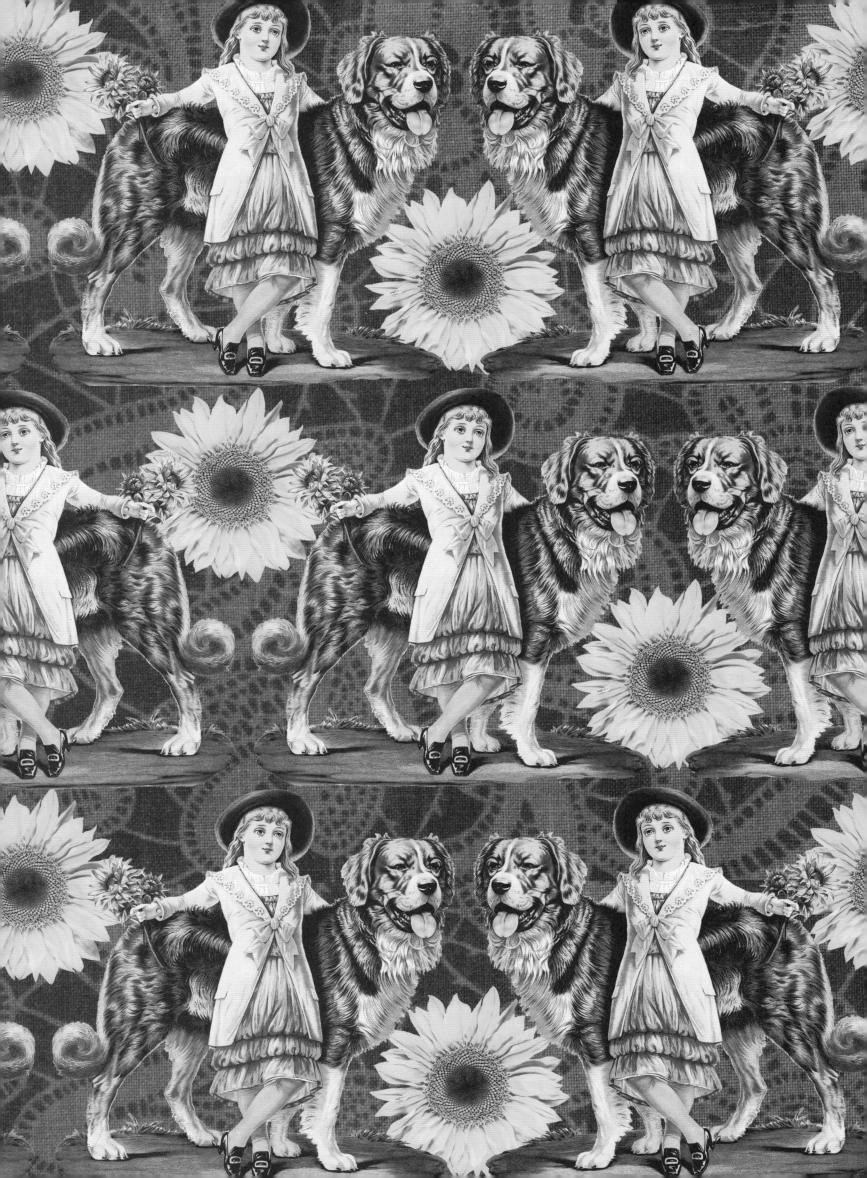

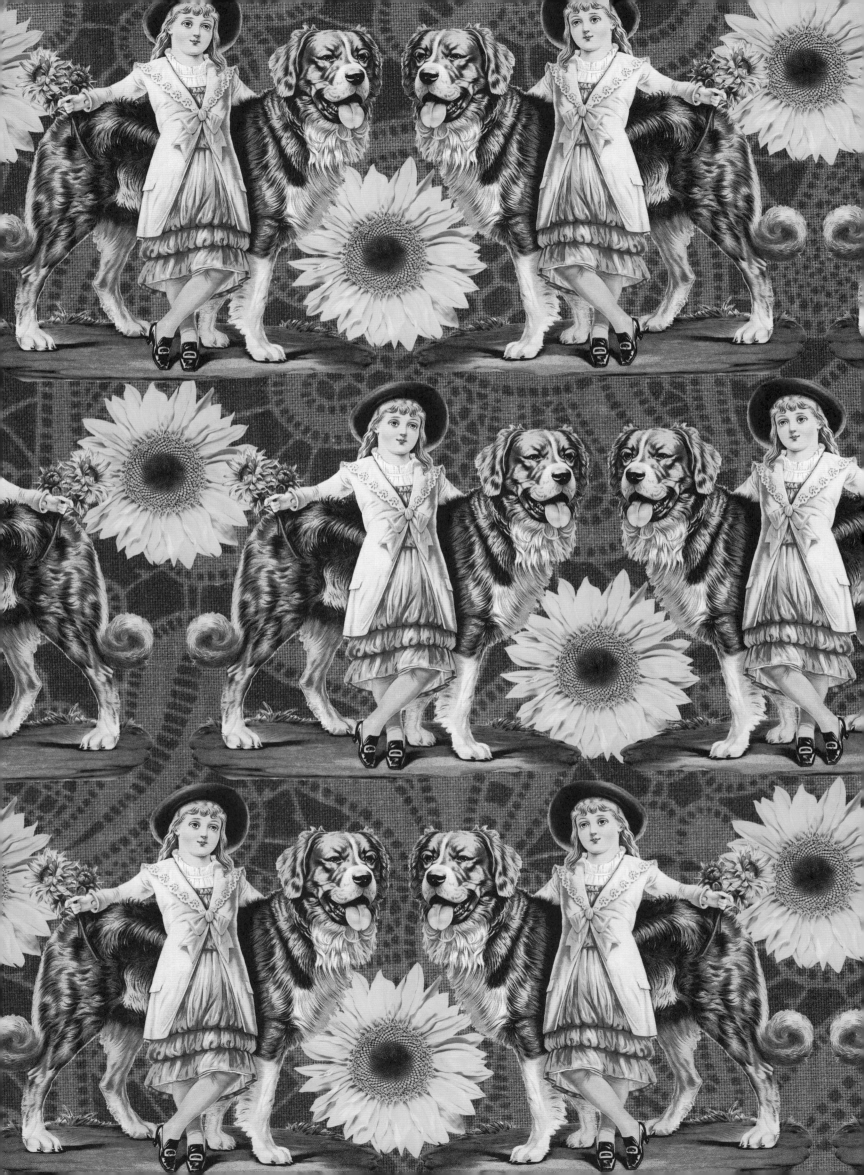

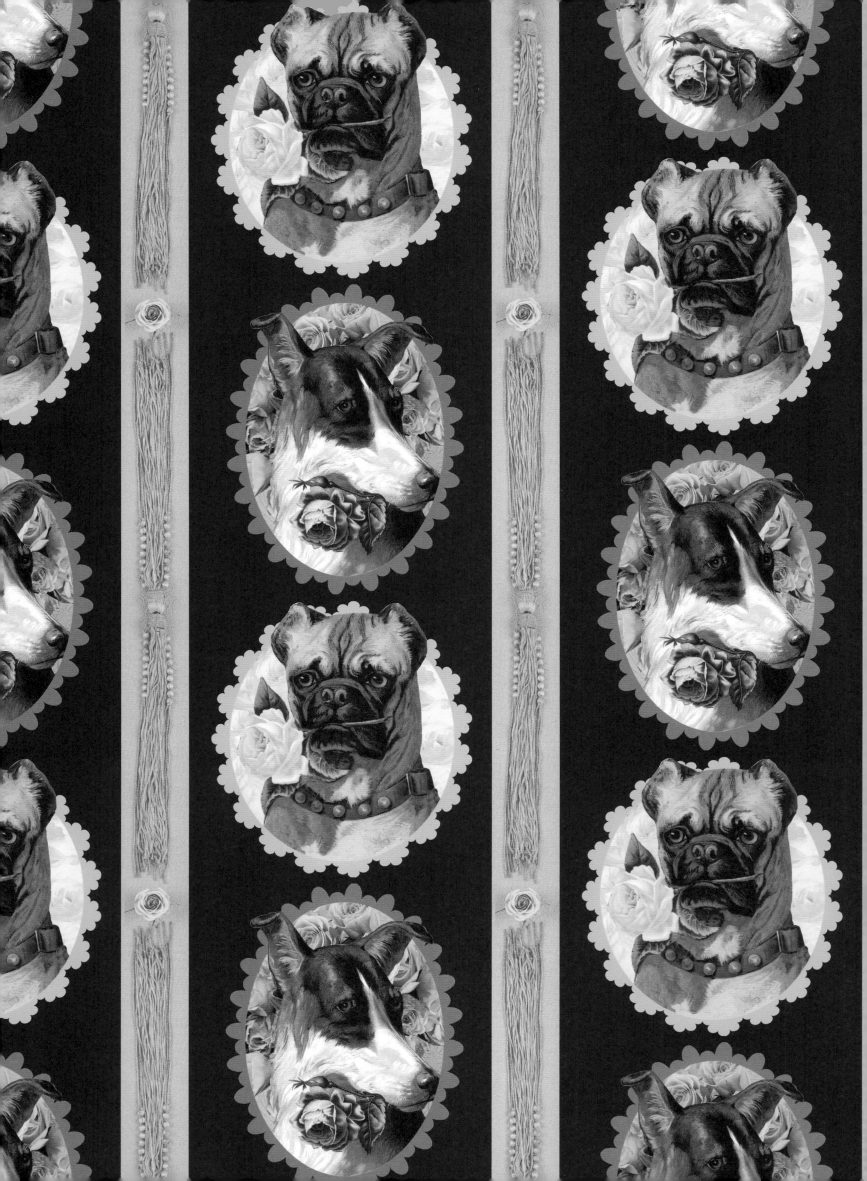

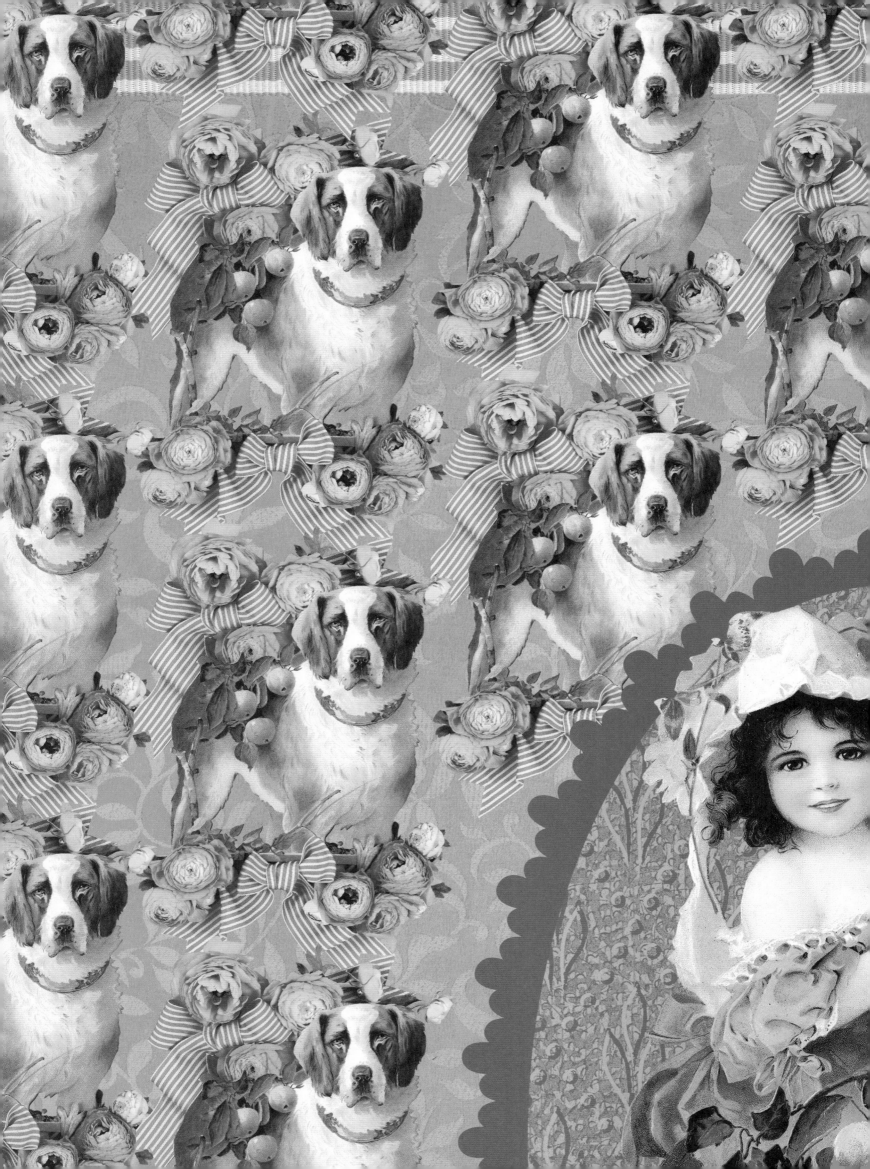

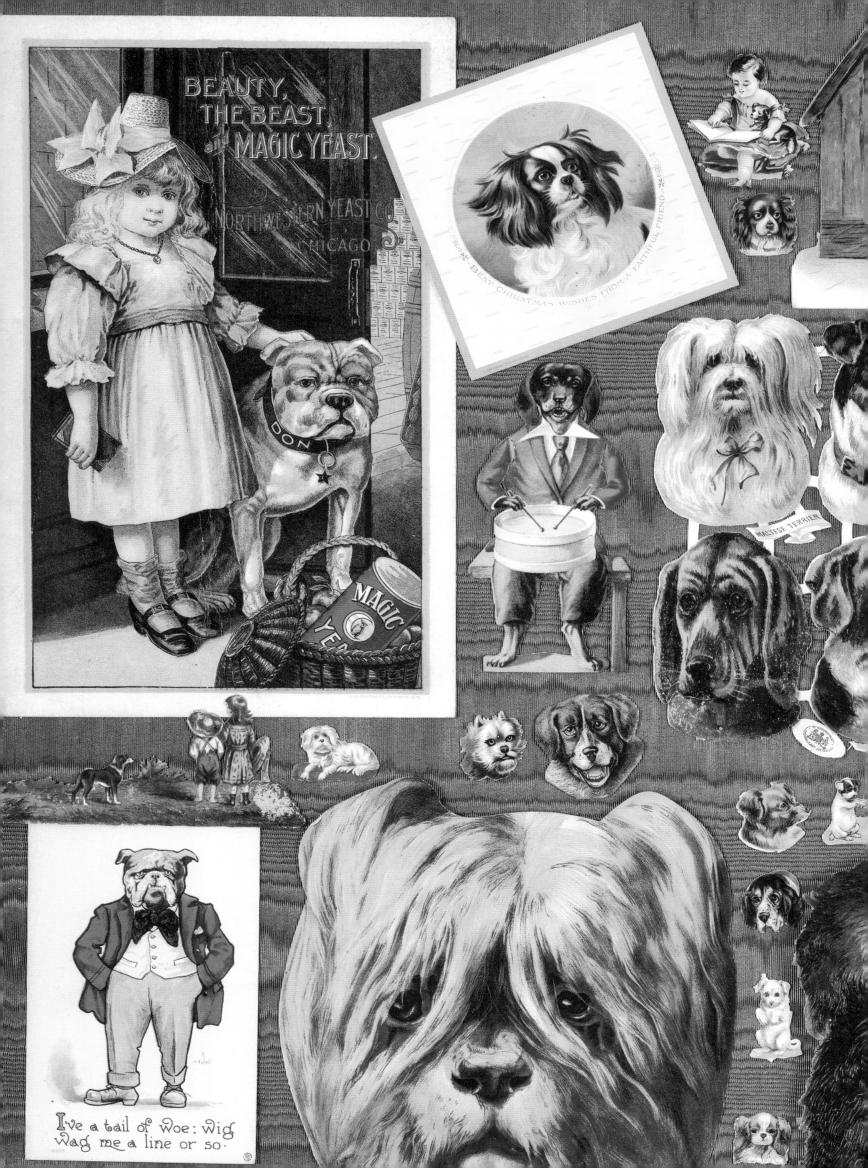

BEAUTY,
THE BEAST,
and MAGIC YEAST

NORTHWESTERN YEAST CO.
CHICAGO

DON

MAGIC YEAST

BEST CHRISTMAS WISHES FROM A FAITHFUL FRIEND

MALTESE TERRIER

I've a tail of Woe; Wig
Wag me a line or so.

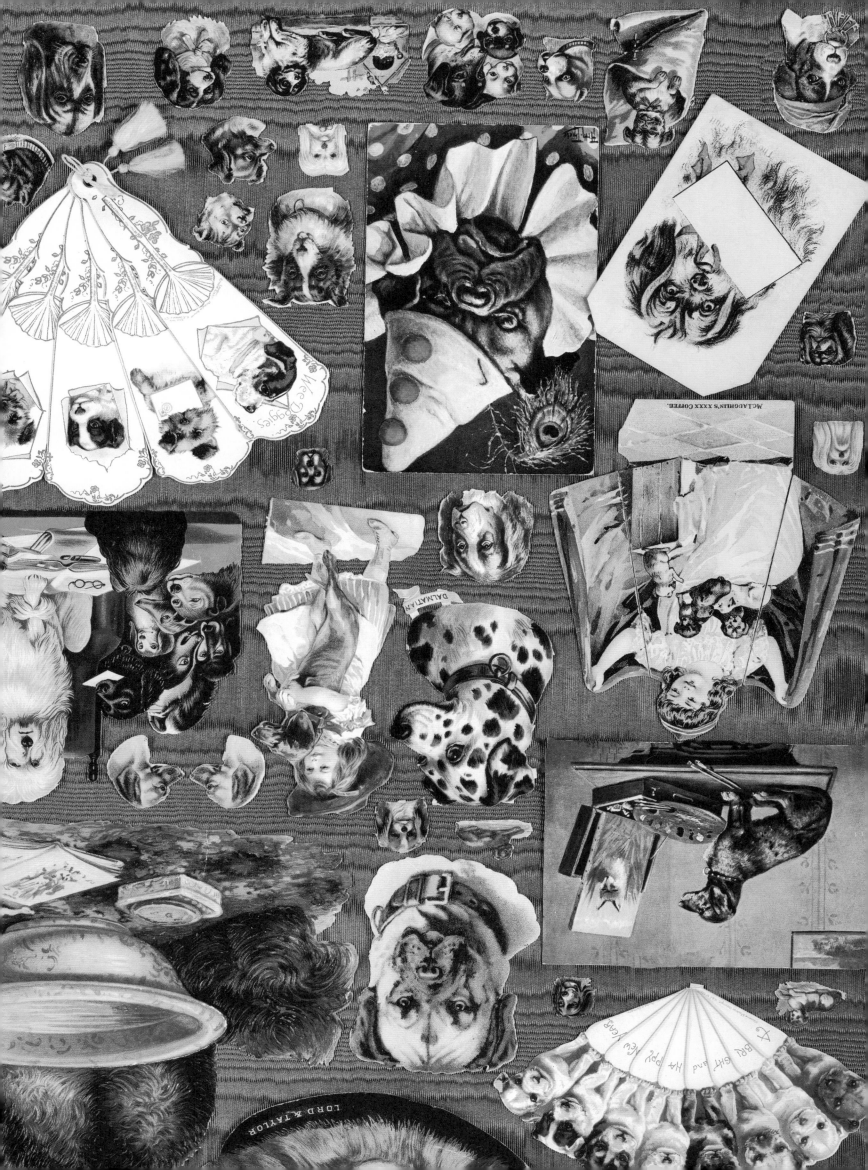

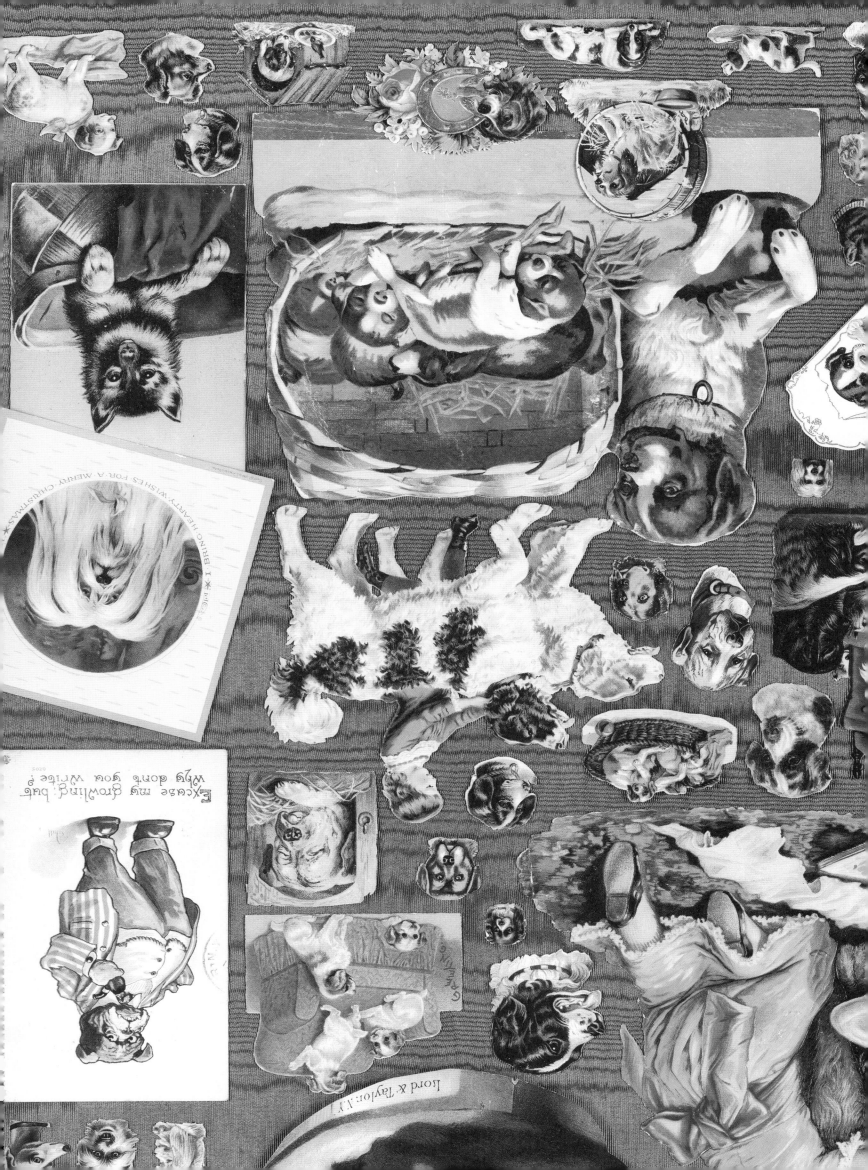

I BRING HEARTY WISHES FOR A MERRY CHRISTMAS

Excuse my growling, but
Why don't you write?

Lord & Taylor, N.Y.

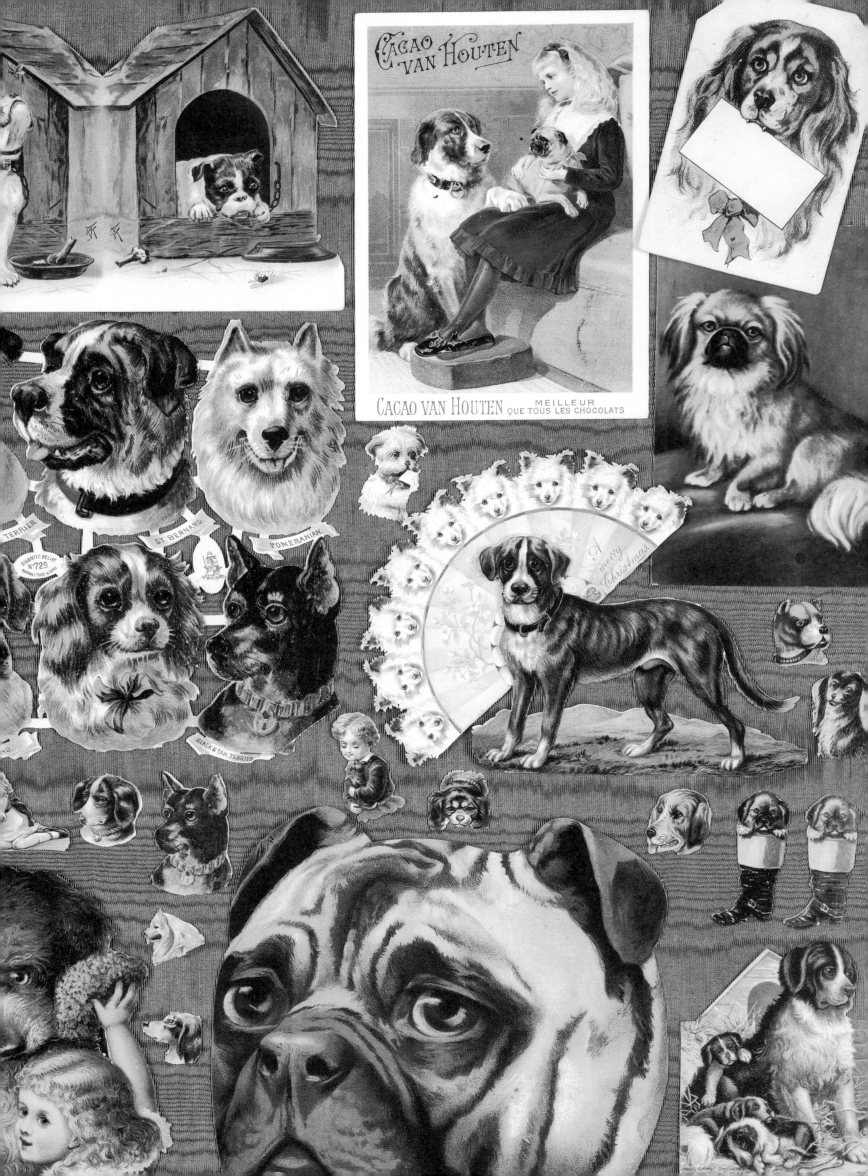

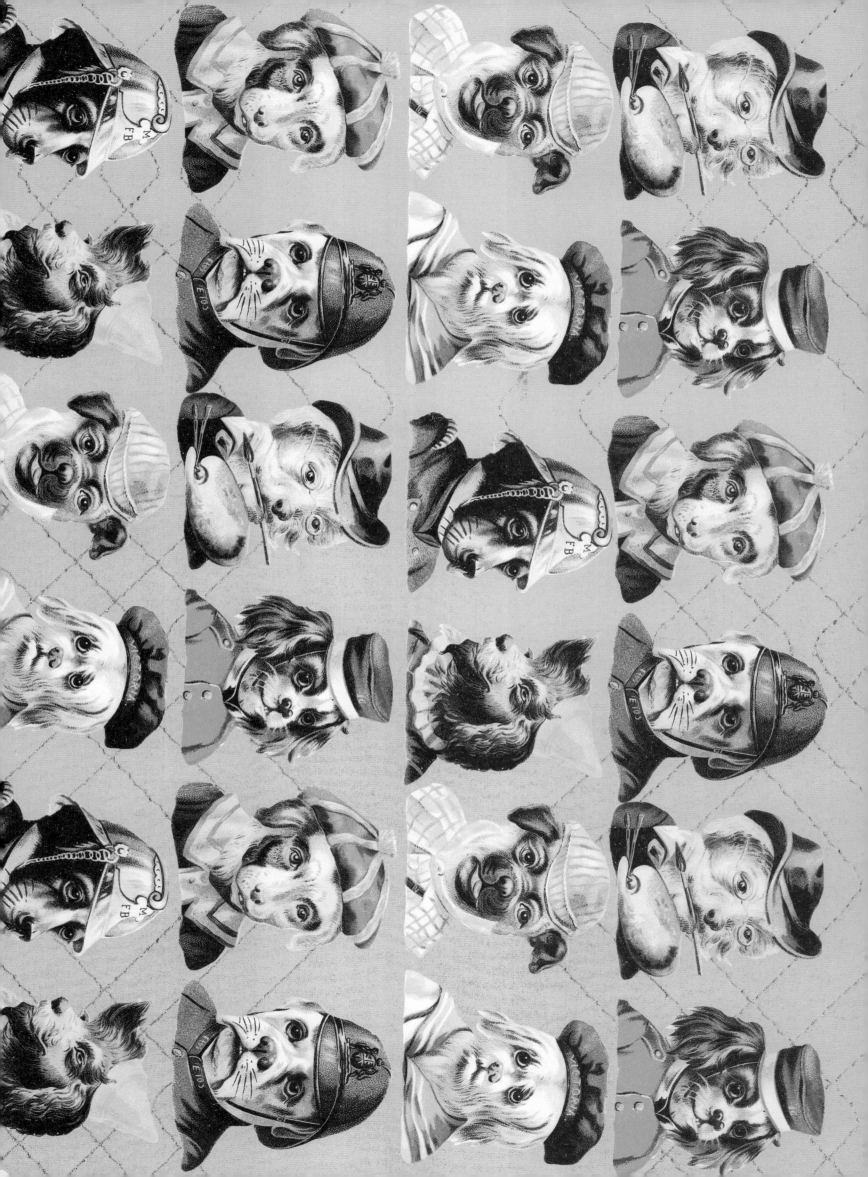

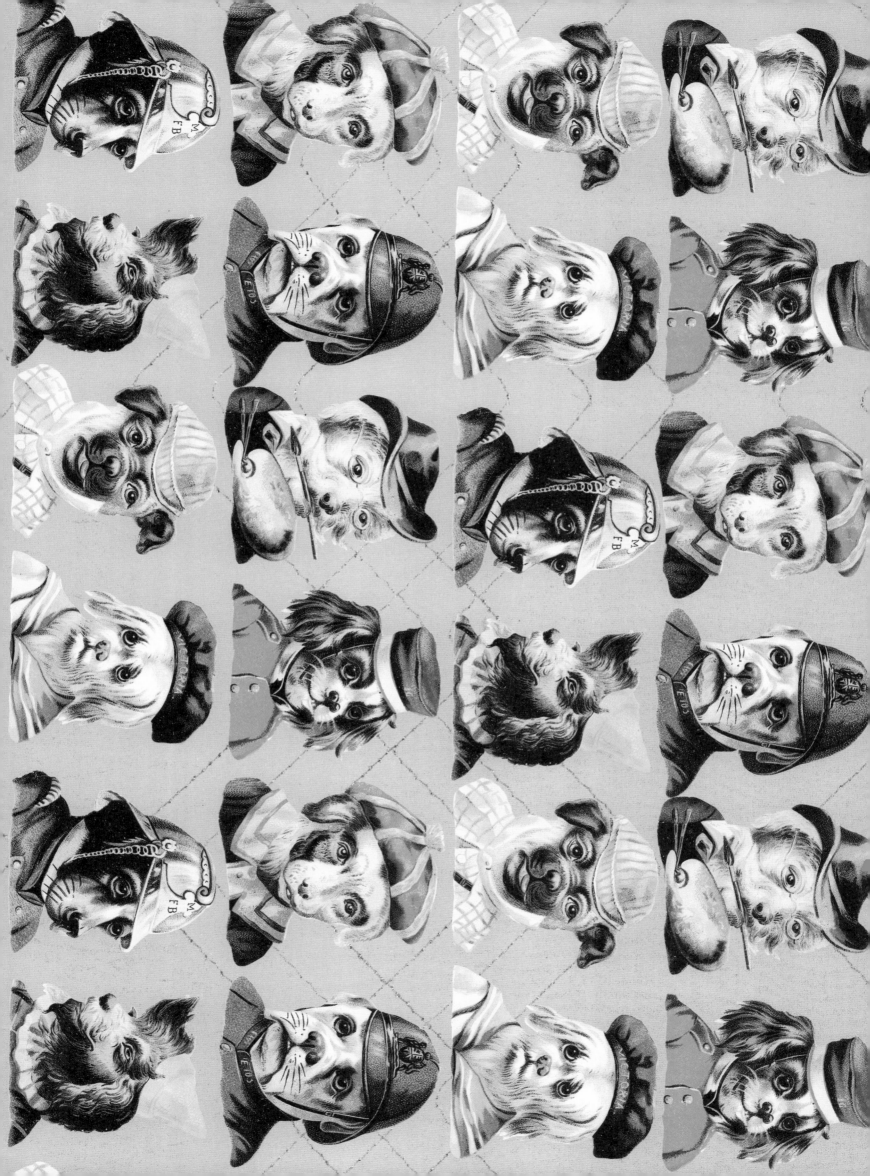

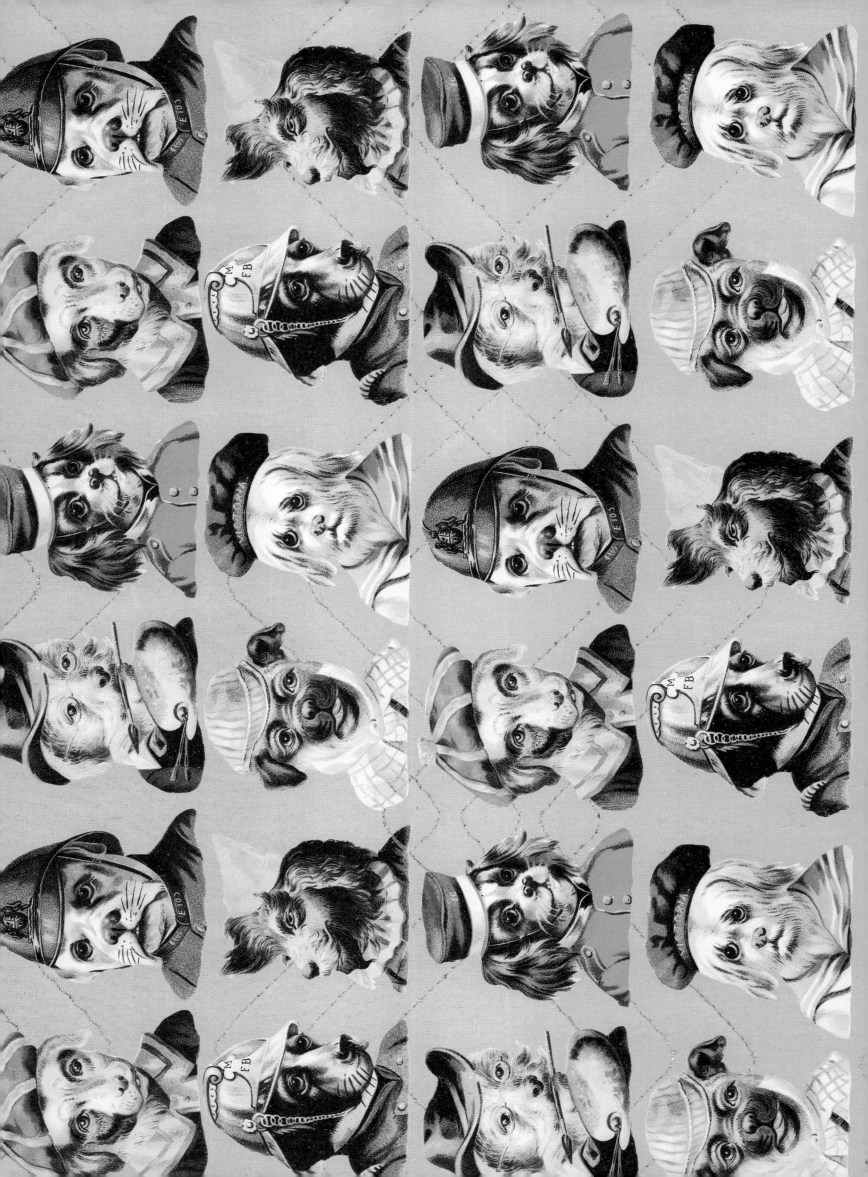

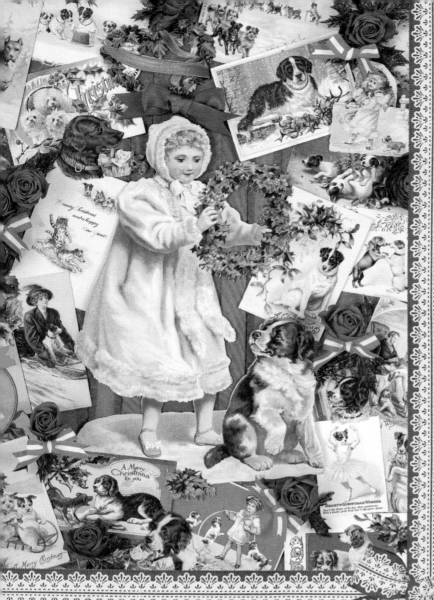
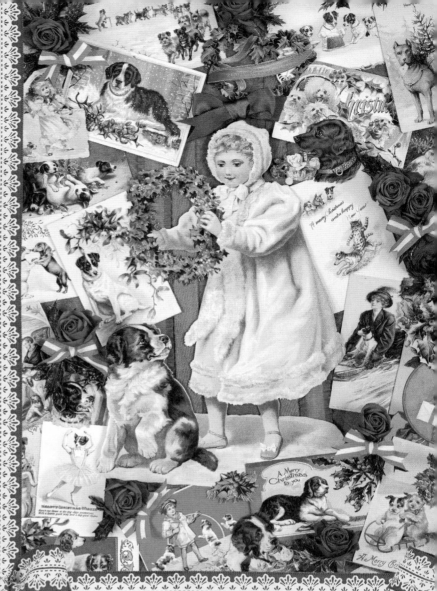
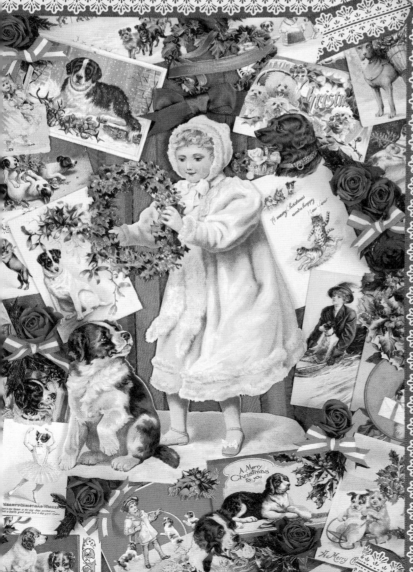

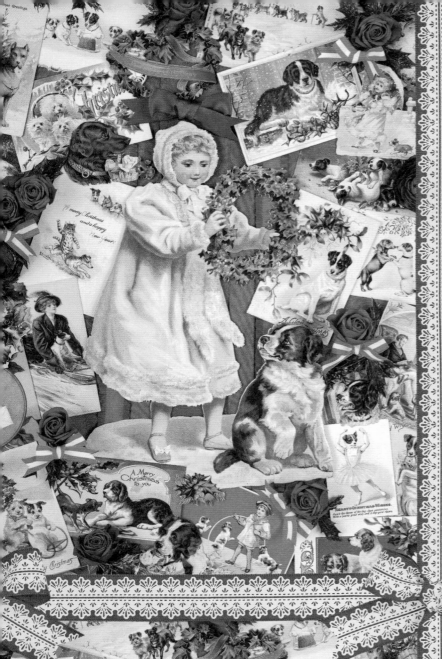